Mona Hatoum

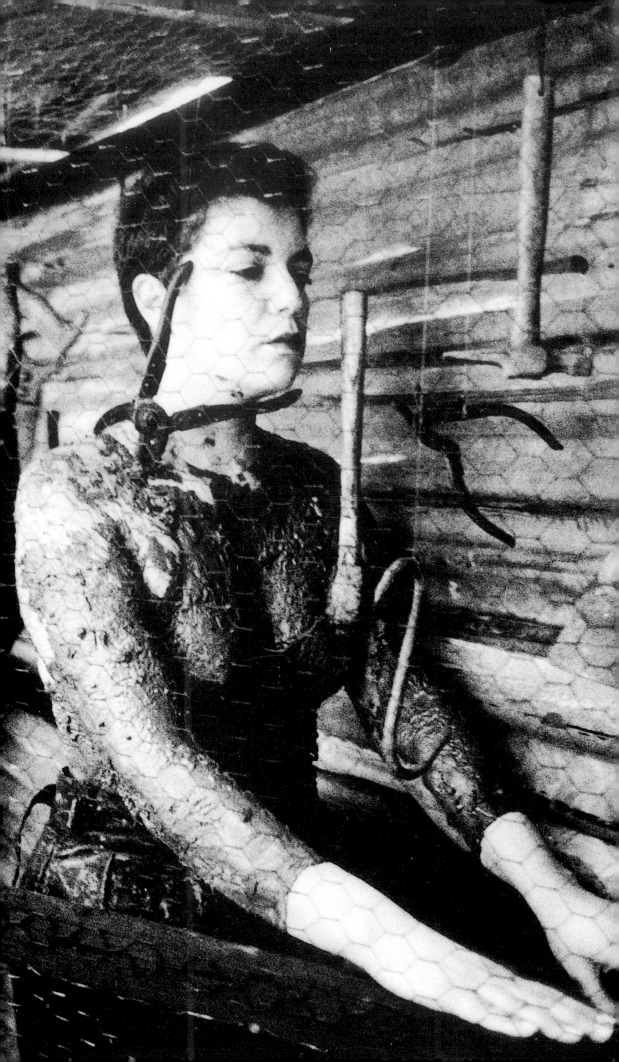

TELLO DI RIVOLI

Mona
Hatoum

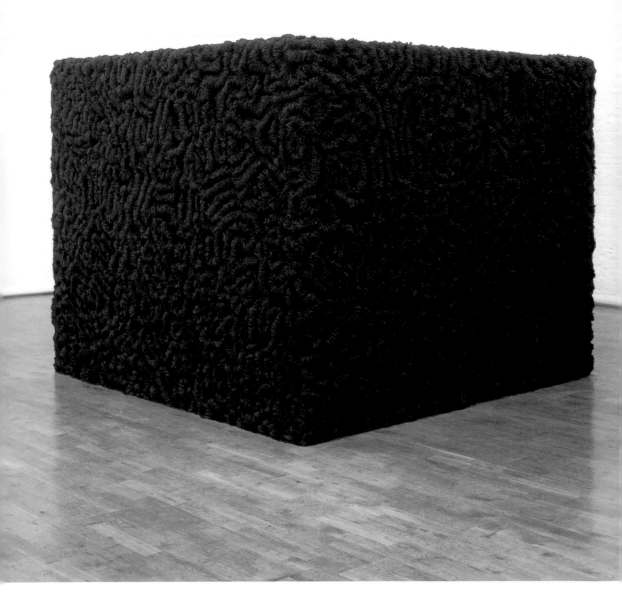

Socle du Monde (*Base del mondo*), 1992-93,
legno, metallo, calamite, limatura di ferro,
164 x 200 x 200 cm
wood, metal, magnets, iron filings,
64½ x 78¾ x 78¾"

Mona Hatoum
Giorgio Verzotti

Mona Hatoum ha detto che fin dalla sua prima visita in un paese tanto diverso dal suo originario Medio-Oriente, nella fattispecie la Gran Bretagna, è stata colpita da un aspetto particolare di quella cultura, cioè dalla separazione netta fra mente e corpo evidente nei comportamenti più comuni e diffusi. L'epoca a cui l'artista si riferisce risale alla metà degli anni Settanta, quando intorno a questi problemi, e in vista di un loro superamento, erano già sorti in Europa diversi movimenti politici e culturali di opposizione. Non c'è tuttavia ragione di pensare che quelle attitudini siano di tanto cambiate se l'artista su questa *schisi* originaria dei saperi dominanti nell'intera cultura occidentale costruisce gran parte del suo lavoro.

Mona Hatoum è nata a Beirut da genitori palestinesi esiliati in Libano a causa della guerra nel loro paese, ed ha frequentato scuole d'arte a Londra. La Gran Bretagna è diventata la sua seconda patria d'adozione, grazie al passaporto inglese che l'impiego del padre le aveva ottenuto, e a causa della guerra civile in Libano, che le impedì il ritorno a Beirut. La permanenza in Occidente e la necessità di vivere in un paese straniero ha inevitabilmente influenzato il lavoro, ne ha orientato le motivazioni verso il confronto, e spesso lo scontro, fra orizzonti storico-culturali diversi e per molti versi opposti.

In questo ha avuto un ruolo decisivo la vicenda autobiografica dell'artista, e ancora di più la consapevolezza del legame fra il suo individuale vissuto e la storia della collettività di cui fa parte. Appartenendo ad un popolo senza patria, l'artista vive se stessa come un soggetto diasporico, e assume l'identità stessa come un processo in fieri, il luogo di uno scambio e, abbiamo detto, di uno scontro. Durante gli anni della scuola e subito dopo, all'inizio

Mona Hatoum has said that when she first visited a European country very different from her native Middle East, in this case it was Great Britain, she was struck by one particular aspect of that culture: namely, the clear separation between mind and body obvious in our most everyday and widespread behavior. The period she refers to was the mid-1970s when various opposition political and cultural movements in Europe were addressing these problems and seeking to overcome them. Yet there is no reason to think that those deeply rooted attitudes have changed that much, since this artist has constructed most of her work on this original schism between dominant modes of knowledge throughout western culture.

Mona Hatoum was born in Beirut to Palestinian parents who were living in exile in Lebanon because of the war in their homeland. Later, Hatoum attended art school in London. Great Britain became her second adopted country with the help of an English passport obtained through her father's work, because the civil war in Lebanon prevented her from returning to Beirut.

Residency in the West and the necessity of living in a foreign country inevitably influenced her work, steering her interest toward a comparison, and often a clash, between different and often opposing historical-cultural horizons.

The artist's autobiographical experience has played a decisive role, as has, to an even greater degree, her awareness of the close tie between her individual experience and the collective history she is part of.

Belonging to a people without a country, the artist herself lives as a displaced subject, and her work reflects on this lack of name and official identity. She makes identity itself a process on exhibit, a place of exchange and, as we have said, collision.

During her school years and immediately afterward, in the early 1980s, Hatoum favor-

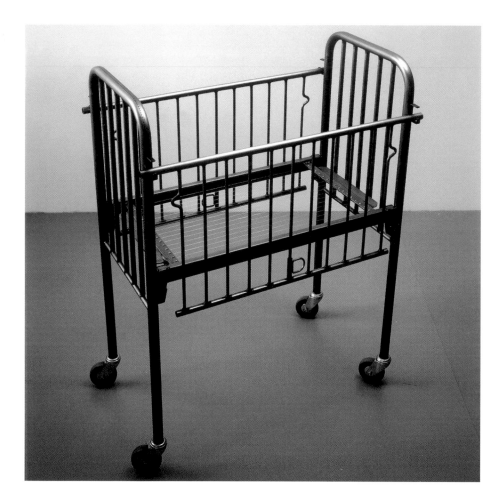

Incommunicado (*Segregato*), 1993,
acciaio dolce, filo metallico, 127 x 49,5 x 95,5 cm
mild steel, wire, 50 x 19½ x 37¾"
Tate Gallery, London

degli anni Ottanta, Hatoum guarda con favore sia ai gruppi di opposizione di cui dicevamo, in particolare al movimento femminista, sia alle espressioni artistiche più radicali e più adatte a veicolare messaggi politici, come le performances e le azioni di strada.

Il corpo è al centro dell'operare dell'artista con un atteggiamento volutamente disturbante e provocatorio nei confronti del pubblico che assiste all'azione in tempo reale. Motivo delle azioni è lo svelamento di determinati tabù comportamentali rispetto a certi aspetti della corporeità "bassa", sulla cui rimozione si fondano le convenzioni che governano i rapporti interpersonali nel nostro mondo. Hatoum intende mostrarli nella loro natura di codici culturali non validi universalmente.

Un interessante progetto di installazione all'Institute of Contemporary Art di Londra (*Waterworks*, *Lavori d'acqua*, 1982) prevedeva l'installazione di telecamere in alcune delle toilettes del centro espositivo collegate a monitors posti nell'ingresso principale, in modo da rendere di pubblico dominio ciò che si sarebbe svolto all'interno dei bagni. Un tale attentato all'intimità del corpo e alla netta separazione fra sfera privata e sfera pubblica non poté essere accettato e fu infine respinto dall'istituzione che ospitava la mostra.

In lavori susseguenti, come *Under Siege* (*Sotto assedio*) del 1982 l'obiettivo dell'artista diviene più marcatamente allusivo al conflitto mediorientale. In quella occasione, Hatoum si presenta nuda rinchiusa dentro una sorta di cabina dalle pareti trasparenti attraverso cui mostra i suoi tentativi, reiterati quanto vani, di reggersi in piedi su una base di fango scivoloso. L'azione dura sette ore, e viene realizzata, quasi profeticamente, una settimana prima dell'invasione del Libano da parte dell'e-

ably viewed the aforementioned opposition groups, particularly the feminist movement, and radical modes of artistic expression suitable for conveying political messages, such as performance art and street actions.

The body is central to her working process, and Hatoum takes a deliberately disturbing and provocative stance toward the public that witnesses her work first hand.

Her work characteristically reveals defined behavioral taboos regarding certain aspects of "low" corporeal material, the repression of which is the basis for the conventions that govern interpersonal relations in our world. Hatoum attempts to expose these taboos as cultural codes that are not universally valid.

An intriguing installation proposal in a group show at the Institute of Contemporary Art in London (Waterworks, 1982) intended to place TV cameras in some of the toilet cubicles of the art center. These cameras were meant to be linked to monitors in the main entrance and, therefore, would have brought the activity going on in the bathroom into the public domain. This sort of assault on the intimacy of the body and on the clear separation between the private and public spheres proved to be unacceptable. Although the show's organizers had initially approved the project, it was, in the end, rejected by the institution that was housing the exhibition.

Under Siege, *1982, demonstrated a political engagement on the part of the artist, alluding to the conflict in the Middle East.* Under Siege *featured the artist, naked, enclosed within a transparent booth, through which one could see her repeated but vain attempts to stand on a surface of slippery mud. The action lasted seven hours and took place, almost prophetically, one week before the Israeli army's invasion of Lebanon, which led to the siege of Beirut.*

In contrast, The Negotiating Table, *1983, dealt with the theme of peace. Hatoum spent*

sercito israeliano. In *The Negotiating Table* (*Il tavolo dei negoziati*) del 1983 interviene invece il tema della pace. Hatoum resta per tre ore in una sala semibuia sdraiata sopra un tavolo illuminato da una lampada con la testa bendata e il corpo rinchiuso in un sacco di plastica trasparente, in cui sono visibili interiora animali, mentre una registrazione sonora trasmette notiziari radiofonici sulla guerra civile e commenti di leaders politici sulla necessità di una soluzione pacifica.

La lunga durata delle performances e la fatica delle azioni in cui l'artista è coinvolta così come la drammaticità del loro impatto visivo apparentano queste prove ai rituali dell'Azionismo viennese e alla Body Art degli anni Settanta, dalle pose cadaveriche di Rudolf Schwarzkoegler alle sequenze autopunitive di Marina Abramović, e comune è anche l'intento di coinvolgere il pubblico attraverso uno shock emotivo, capace di ricondurlo, come voleva Antonin Artaud, alla radice dei suoi stessi conflitti interiori.

I riferimenti più esplicitamente politici di Mona Hatoum fanno piuttosto pensare che il suo ricorso allo shock mira a tematizzare l'irrimediabile passività degli spettatori, la loro condizione di vuoti ricettori posti di fronte alla spettacolarizzazione mediatica dei conflitti collettivi. Più interlocutorie verso il pubblico sono le azioni di strada, che l'artista realizza nel 1985 nel quartiere di Brixton, a Londra. La più famosa fra queste, *Roadworks* (*Lavori per strada*) 1985, ha dato vita all'opera fotografica *Performance Still* (*Immagine di performance*), 1985-95: a piedi nudi, l'artista cammina lungo i marciapiedi con due scarponi legati ciascuno alle caviglie tramite le stringhe, così da sembrare seguita ad ogni passo da un fantasma militaresco. Gli scarponi in effetti sono i Doc Martens

three hours in a semi-darkened room, stretched out on a table illuminated by a single light bulb. Her face was bandaged and her body, covered in animal entrails, was enclosed in a transparent, plastic bag. A tape transmitted radio broadcasts on the civil war and comments from political leaders on the need for a peaceful solution.

The long duration of Hatoum's performances and the effort involved in the actions, as well as the dramatic nature of their visual impact, link these pieces to Viennese Action Art rituals and to Body Art from the 1970s, from Rudolf Schwarzkoegler's corpse-like stills to Marina Abramović's self-punishing sequences. Hatoum shares these artists' desire to involve the public through emotional shock, with the hoped-for result of leading people, as Antonin Artaud wished, to the root of their own inner conflicts. However, Mona Hatoum's most explicitly political references lead one to think that her recourse to shock is intended to thematicize observers' irremediable passivity, their condition as empty receptacles faced with the mass-media representation of dramatic collective conflicts.

The street actions that the artist staged in 1985 in Brixton, London, had a more interlocutory relationship with the public. The most famous of these resulted in the performance Roadworks, 1985, *documented in the photographic piece,* Performance Still, 1985-95. *Standing barefoot and wearing workmen's overalls, the artist walked along the pavements with big boots tied to her ankles that followed her at every step like a military phantom. The boots were actually Doc Martens, usually worn by both the police and Nazi skinheads, and the action took place, significantly, in a predominantly black, working-class area, already the scene of racial clashes.*

In all these works, the body is defined as a physical entity (the body of the artist, her co-performers, the public) and, at the same time,

Light Sentence (Lieve sentenza), 1992, ▶
gabbie in rete metallica, lampadina, filo elettrico, motore,
198 x 185 x 490 cm
wire mesh lockers, light bulb, electric wire, motor, 78 x 73 x 193"
Musée national d'art moderne Centre Georges Pompidou, Paris

Marrow (Midollo), 1996,
gomma, 30,5 x 145 x 114 cm
rubber, 12 x 57 x 45"

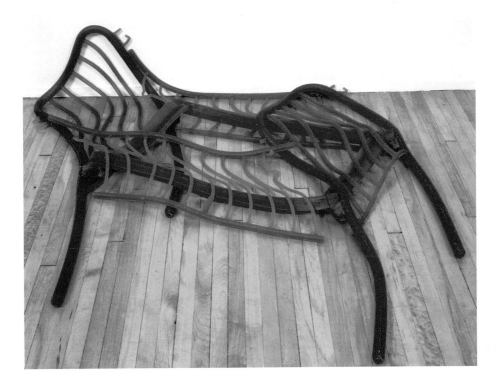

usati sia dalle forze di polizia che dai nazi-skin, e l'azione avviene in una zona proletaria a maggioranza nera, già teatro di scontri razziali. In tutte queste operazioni il corpo viene individuato nella sua fisica entità (il corpo dell'artista, dei suoi partners nelle azioni, del pubblico) e contemporaneamente nella sua valenza metaforica (il corpo sociale, la collettività alla quale l'artista si rivolge) considerandolo in ogni caso come il luogo dove agiscono le censure determinate dall'ordine sociale e dalla sua legittimazione ideologica. Indicare queste censure è il compito che l'artista si assume, a partire anche dai valori di vita diversi di cui è portatrice. Tuttavia il suo lavoro vale anche come riflessione autocritica su tali valori e soprattutto sulla categoria del "politico" come referente dei linguaggi artistici.

metaphorically (the social body, the collectivity the artist is addressing). In all cases, the body is dealt with as a staging ground for censorship defined by the social order and by its ideological legitimization.
The indication of this censorship and its origins is the task that the artist has taken on, at times using values other than her own as a point of departure. Yet her work is also valid as a self-critical reflection on those values, particularly the category of the "political" as a referent for artistic languages.
Two other works reflecting a similar approach are particularly expressive. Measures of Distance, *1988, is a video where photographic images of a woman in a shower are superimposed by a handwritten Arabic text, where the cursive marks seem like an embroidered veil.*
The woman is Hatoum's mother, and the superimposed text is from a letter she sent to

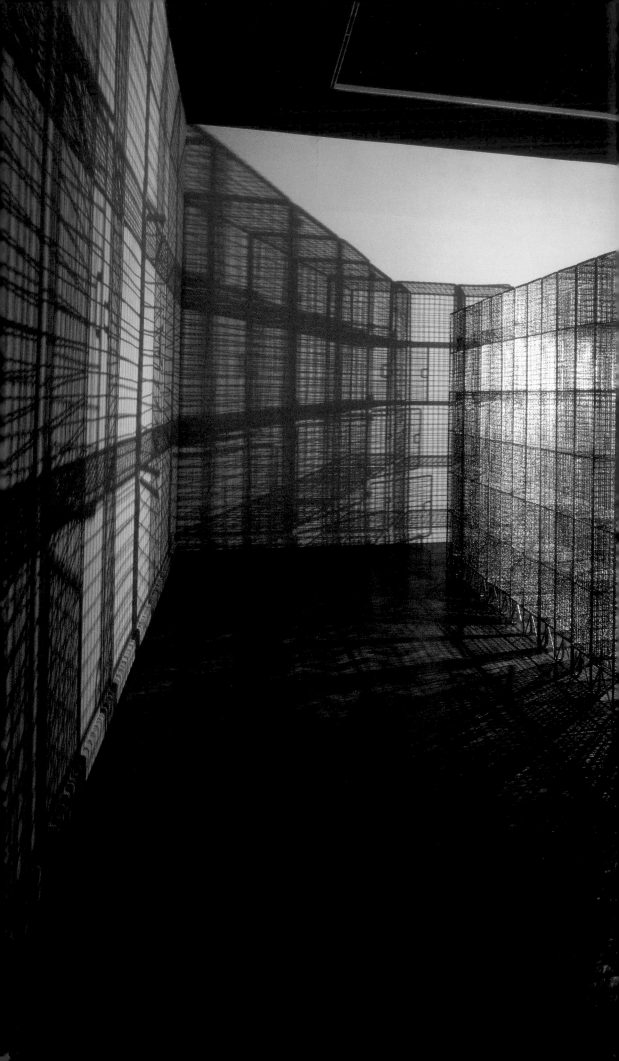

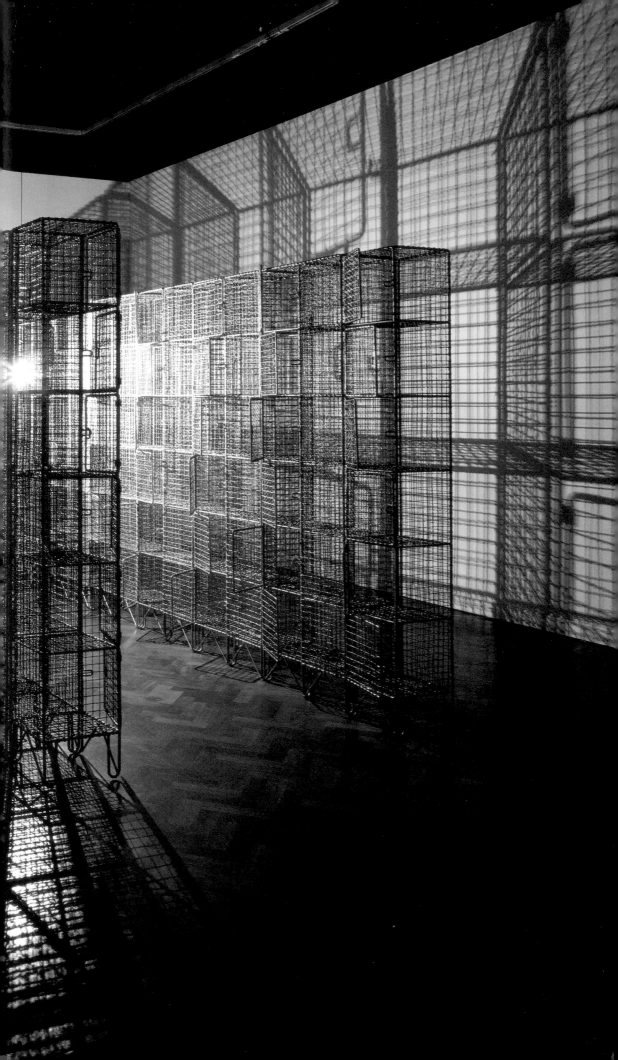

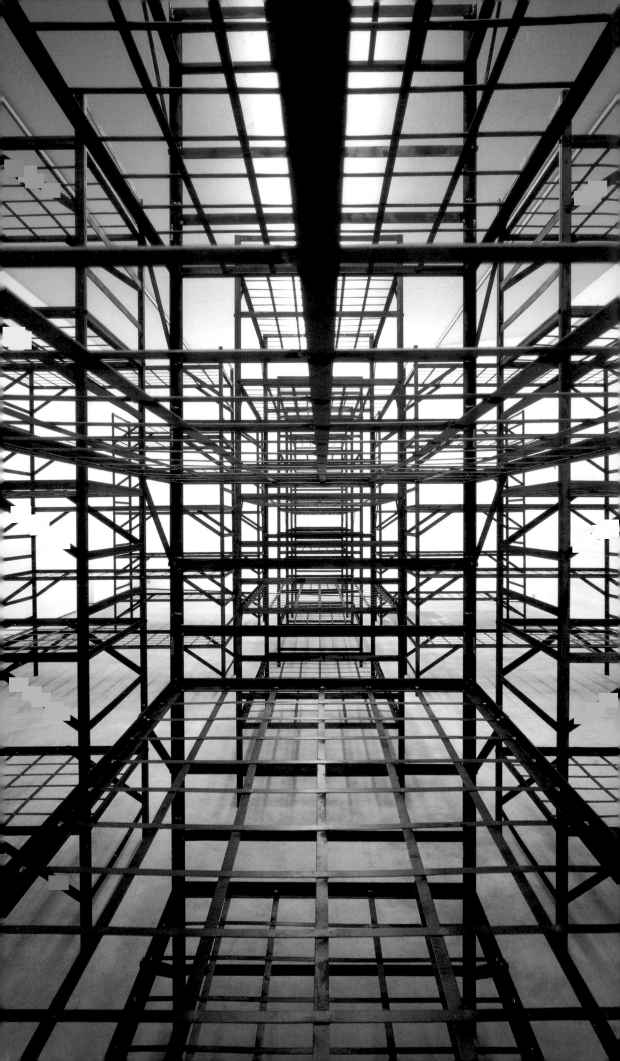

Quarters (Alloggi), 1996,
acciaio dolce, 275 x 512 x 1296 cm
mild steel, 108½ x 237 x 503"
Installazione/installation, Viafarini, Milano

Due lavori risultano particolarmente significativi dei termini che assume simile riflessione. *Measures of Distance (Misure di distanza)* è un video del 1988 dove scorrono immagini fotografiche di una donna sotto la doccia sulle quali appare sovrimpresso un testo in arabo scritto a mano, che nei suoi segni corsivi sembra un velo ricamato. La donna è la madre dell'artista e il testo sovrimpresso è quello di una lettera che le ha indirizzato a Londra, e che Hatoum legge a commento sonoro della sequenza visiva. In sottofondo, un dialogo fra le due donne rimanda parole e risate. Sono precisamente l'intimità del rapporto fra madre e figlia, le parole dell'affettività e della dimensione quotidiana, i sentimenti e la sessualità oggetto del loro dialogo, a motivare una riflessione di ordine politico. Essa non potrà che risalire dall'individualità dei personaggi coinvolti alla loro storia di esilio, e a quella della collettività di cui sono parte integrante, per la quale i meri concetti di casa, famiglia, tradizione diventano forzatamente oggetti di rivendicazione. Essa inoltre metterà a confronto gli stili di vita di una dimensione culturale diversa dalla nostra con i nostri pregiudizi intorno ad essa; così l'associazione fra la femminilità e la cultura araba non ci mostra una donna velata e sottomessa, ma una matrona nuda e ridente che parla della sua sessualità. *The Light at the End (La luce alla fine)* è invece un'installazione del 1989, e secondo molta critica segna una svolta decisiva nel lavoro di Mona Hatoum. In un angolo di una stanza buia lo spettatore discerne una struttura rettangolare al cui interno stanno sei barre verticali luminose. Ad una visione ravvicinata, il calore che emana dalla struttura rivela che le barre sono in realtà resistenze incandescenti, e perciò estremamente pericolose. Dopo aver richiamato alla memoria la pulizia

London, which the daughter reads aloud, on a sound track that accompanies the visual sequence.In the background, a laughter-filled dialogue takes place between the two women.
The intimacy of the mother-daughter relationship, the words of affection and the everyday dimension, the sentiments and sexuality that are the subject of their dialogue, are precisely what motivate reflections on a political plane.
The work cannot help but move from the individuality of the personalities involved to their story of exile and to the story of the group of which they are an integral part, for whom mere concepts of home, family, tradition and identity become, of necessity, subjects of vindication.
The work also points to a question of cultural differences and Western prejudices about other cultures. Thus the association of femininity and Arab culture does not present us with a veiled, submissive woman, but with a powerful one, standing naked, laughing and openly discussing her sexuality.
The Light at the End, 1989, was an installation that, according to many critics, marked a decisive turning point in Mona Hatoum's work.
In a corner of a darkened room, the spectator could discern a rectangular structure containing six vertical, luminous bars. On closer examination, the heat emanating from the structure revealed that the bars actually contained incandescent, and thus extremely dangerous, resistors. After bringing to mind the formal clean lines of minimalist structures and the color-light of Dan Flavin, the work was transformed into an alarming device, in a way that was by no means metaphorical.
In The Light at the End, the body is no longer present, but is implicated dramatically in the real danger to which it is exposed and the physical discomfort to which it is subjected. A specifically political content is no longer clearly discernable, but is implied by the

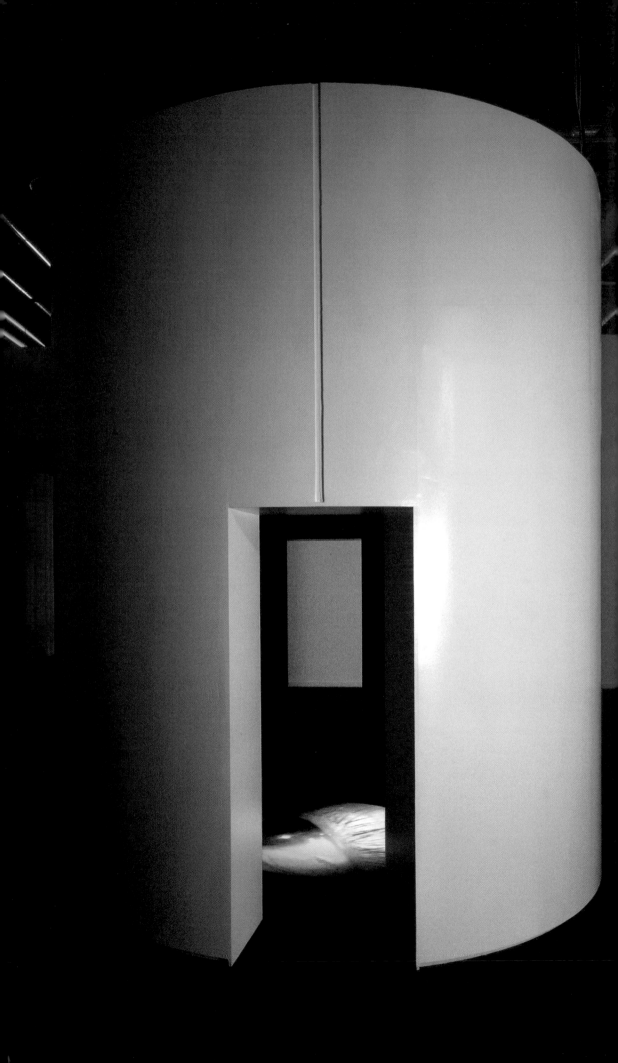

Corps étranger (*Corpo estraneo*), 1994,
struttura in legno, video proiettore, video registratore,
amplificatore, quattro casse acustiche, 350 x 300 x 300 cm
wooden structure, video projector, video player,
amplifier, four speakers, 138 x 118 x 118"
Musée national d'art moderne Centre Georges Pompidou, Paris

formale delle strutture minimaliste e il colore-luce di Dan Flavin, l'opera si trasforma in un dispositivo allarmante in un senso per nulla metaforico. Il corpo qui non è più presente, ma viene tematizzato drammaticamente nel pericolo reale a cui viene condotto e al disagio fisico a cui si sottopone. Un contenuto specificamente politico non è più rintracciabile, ma ricorre nell'aggressività con cui l'artista costruisce questa trappola percettiva, dalle insidie non solo virtuali.

Il linguaggio da esplicito si fa ambiguo, sfrutta la ricchezza semantica insita nei linguaggi dell'arte che, a differenza di quelli dell'ideologia, consentono una testimonianza del reale più efficace proprio in quanto lo sottraggono alle definizioni univoche, lo spostano dal mondo squadrato della certezza a quello multiforme delle possibilità, lo rivelano come il luogo stesso della contraddizione.

Hatoum costruisce dunque ambienti fisicamente insidiosi, come i taglienti fili di acciaio tirati da parete a parete, ad altezza di caviglie, di inguine, di spalle, che disegnano un percorso nella Mario Flecha Gallery di Londra (*Untitled*, *Senza titolo*, 1992), o tesi comunque a coinvolgere intensamente lo spettatore sul piano psicologico. In *Light Sentence* (*Lieve sentenza*), 1992, siamo di nuovo in una sala semibuia, al cui centro si erge una struttura chiusa su tre lati fatta di piccole gabbie metalliche sovrapposte.

L'unica fonte luminosa è una lampadina appesa ad un filo che pende dal soffitto e che lentamente scende al centro della costruzione fino a toccare il pavimento per poi lentamente risalire. La luce proietta ai muri l'ombra delle griglie metalliche che formano le pareti delle gabbie, e scendendo le sposta verso l'alto cosicché queste sembrano ingigantirsi, con un procedere

aggressiveness with which the artist has constructed a perceptual trap, with snares that are more than merely virtual.

Hatoum's language has moved from the explicit or strongly allusive to the ambiguous, and it takes advantage of the semantic riches inherent in the discourses of art. Unlike the language of ideology, this discourse allows a more efficacious testimony to reality, precisely because it removes itself from unambiguous definitions and shifts from a world framed by certainty to a multiform universe of possibilities, revealed as a place of contradictions.

Hatoum's environments can be physically treacherous: razor-sharp steel wires strung from wall to wall, at ankle, groin and shoulder height, defined a path through the Mario Flecha Gallery in London (Untitled, *1992). Or her work can involve the spectator on an intense psychological level, as in* Light Sentence *(1992). A vertical structure closed on three sides, made of small, stacked-up metal cages stood in a semi-darkened room. The only light source was a light bulb hanging from the ceiling by a wire, which slowly descended to the center of the structure until it touched the floor, then slowly rose again. On the walls, the light bulb projected the shadow of the metal grids that formed the walls of the cages, and when the light bulb descended, the projections shifted upward and seemed to grow larger, in a vaguely oppressive process, then vibrate when the light bulb touched the ground, quivering. The semi-darkness and the movement of the shadows in the faint light created an overall sinister effect and conveyed a claustrophobic feeling, accentuated by the appearance of the structure. Although the cages had one open side, they obviously evoked images of segregation, like animals in a laboratory.*

Hatoum's sculptures are theoretically linked to environments like these, full of hidden deceptions, and almost seem to have been conceived as furnishings for them. Incommunicado

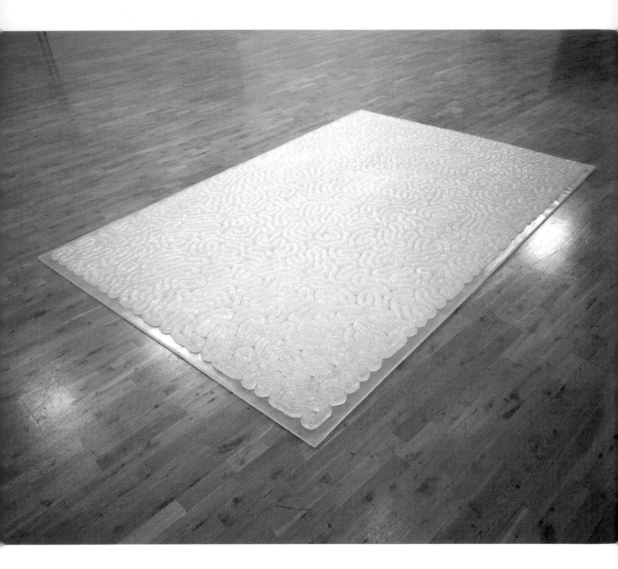

Entrails Carpet (Tappeto di visceri), 1995,
gomma al silicone, 4,5 x 198 x 297 cm
silicone rubber, 1¾ x 78 x 117"
Fabric Workshop and Museum, Philadelphia

Prayer Mat (Tappeto da preghiera), 1995, ▶
spilli in ottone nichelato, bussola in ottone,
tela, colla, 1,5 x 67 x 112 cm
nickel-plated brass pin, brass compass,
canvas, glue, ½ x 26½ x 44"
Los Angeles County Museum, Los Angeles

vagamente opprimente, per poi vibrare quando la lampadina tocca terra oscillando. La semioscurità e il movimento delle ombre alla fioca luce della lampadina procurano un effetto complessivamente sinistro, e diffondono una sensazione claustrofobica accentuata dall'aspetto della costruzione: le gabbie, nonostante abbiano un lato aperto, fanno evidentemente pensare alla segregazione, come nel caso di animali da laboratorio. Idealmente collegate a simili ambienti sono le sculture che Hatoum realizza quasi pensandole come loro arredi, a cui si confanno per via delle insidie che nascondono. *Incommunicado (Segregato)*, 1993, per esempio è un lettino per bambini che mostra in luogo di una rete per il materasso una teoria di fili di ferro e che nella struttura tubolare in metallo richiama i letti d'ospedale. Tale richiamo è ancor più evidente in *Silence (Silenzio)*, 1994, che ha la stessa forma, non ha base ed è realizzato in tubi di vetro, mentre *Marrow (Midollo)*, 1996, si presenta come un oggetto floscio, essendo fatto di gomma. Simili oggetti si faranno numerosi nella produzione anche recente dell'artista, da *Divan Bed (Divano letto)*, 1996 e *Dormeuse*, 1998, dove un rigido ferro mima la morbidezza dei mobili imbottiti, fino a *Untitled (Wheelchair)*, *(Senza titolo - Sedia a rotelle)* del 1998, sedia a rotelle in acciaio provvista di lame affilate in luogo delle impugnature.
Un particolare interesse assumono le opere in forma di tappeti, adeguatamente collocate a terra, ma realizzate nei materiali più incongrui. *Prayer Mat, Pin Carpet (Tappeto da preghiera, Tappeto di spilli)*, 1995 e *Doormat (Zerbino)*, 1996 sono infatti superfici ricoperte di spilli dalla punta rivolta verso l'alto, così da contraddire ironicamente l'uso a cui sarebbero associati.

(1993), for example, features a child's crib with a tubular metal structure, which brings to mind a hospital bed. In place of a base to support a mattress, it has a series of metal wires. This sort of reference is even more obvious in Silence *(1994), which is a bottomless bed made from glass tubes.* Marrow *(1996) is a collapsed bed frame, made of rubber, without a solid structure to keep it upright.*
The artist's recent work is characterized by numerous similar objects, from Divan Bed *(1996) to* Dormeuse *(1998), where rigid iron mimics the softness of upholstered furniture; in the case of* Untitled (Wheelchair) *(1998), a stainless-steel wheelchair comes equipped with knife blades in place of handles. Her carpet pieces, appropriately installed on the floor but made of the most incongruous materials, are particularly interesting.* Prayer Mat, Pin Carpet *(1995) and* Doormat*(1996) are surfaces made up of pins, pointing upward, thus ironically contradicting the use with which they are associated.* Doormat, *with the word "welcome" legible in negative at the center, associates the mat with a device that has a dual meaning, simultaneously inviting and repulsive. The associations of* Prayer Mat *are more complex and perhaps indicative of the direction the artist's work is taking. While Muslims*

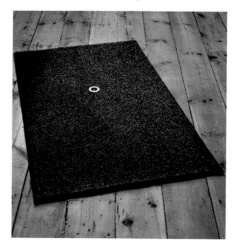

Recollection (Ricordo), 1995,
capelli, telaio e tavolo in legno, dimensioni
determinate dall'ambiente (particolare)
hair, wooden loom and table, dimensions
determined by the space (detail)
De Vleeshal, Middelburg

Doormat, con la parola *welcome* leggibile in negativo al suo centro associa lo zerbino ad un dispositivo dal doppio valore, attraente e repulsivo ad un tempo, mentre le associazioni di *Prayer Mat* sono più complesse e forse indicative delle direzioni che prende il lavoro dell'artista. Se i musulmani in preghiera devono sempre rivolgersi verso la Mecca, molti di quelli che vivono a Londra possono usufruire di tappeti provvisti di una bussola incastonata nel tessuto per facilitare l'orientamento verso est. Questa geniale risoluzione viene usata dall'artista per porre nel lavoro un doppio riferimento, che tocca sia la cultura mediorientale colta in uno dei suoi aspetti salienti, quello religioso, sia la cultura occidentale colta in uno dei suoi ambiti più elitari, quello dell'arte d'avanguardia.

È inevitabile infatti che la bussola rimandi a Giovanni Anselmo, esponente di quell'Arte Povera a cui Hatoum ha guardato come alla più interessante fra le forme d'espressività artistica occidentale, mentre la semplificazione geometrizzante dell'opera, il suo formato rettangolare e la sua dimensione "rasoterra" rimanda ovviamente al Minimalismo. In tutto il suo lavoro Hatoum si serve del testo minimalista per trasgredirlo, lo adotta come repertorio formale per mostrarne (e rovesciarne) le premesse ideologiche in direzione di un lavoro di analisi su quella *schisi* fra corpo e mente che costituisce il suo programma. Del resto il Minimalismo, che ha posto in primo piano i valori della razionalità, ha "decorporeizzato" l'opera considerandola come un assioma teorico e astraendola da ogni contesto di senso, è stato affrontato o riletto da diverse donne artiste come una tendenza prettamente maschile, e perciò rigettato o appunto accolto e trasgredito.

Mona Hatoum per esempio dà importan-

must always face toward Mecca when praying, many of them who live in London can take advantage of prayer rugs that come with a compass attached to the surface to facilitate their eastward orientation. This clever resolution is used by the artist to introduce a double reference to both mid-eastern culture in one of its salient aspects, the religious, and western culture in one of its most elitist contexts, avant-garde art.

Indeed, it is inevitable that this piece would bring to mind Giovanni Anselmo's compasses imbedded in granite. Anselmo is a protagonist of Arte Povera, the contemporary movement Hatoum has regarded as one of the most interesting forms of artistic expression typical of our world, while the geometric simplification of the piece, its rectangular format and "close to the ground" configuration, obviously refers to Minimalism.

In all her work, Hatoum avails herself of the minimalist text in order to transgress it. She adopts it as a formal repertory to demonstrate (or overturn) its ideological premises in order to analyze the mind-body schism that constitutes her program.

Emphasizing values of rationality, Minimalism sought to "de-corporealize" the art object, considering it more as a theoretical axiom and abstracting it from any context of meaning. Subsequently, various women artists have addressed or re-interpreted Minimalism as a typically male tendency to be rejected or, as in the case of Hatoum, to be understood and transgressed.

For example, Mona Hatoum gives importance to the context, which conditions the perception of the work and therefore its meaning. The artist adopts a formal language but restores it to the context of relationships of power at work in the society from which it originated, as with the grid, a modernist emblem par excellence.

The grid, that is the orthogonal intersection of straight lines or planes, appears in the con-

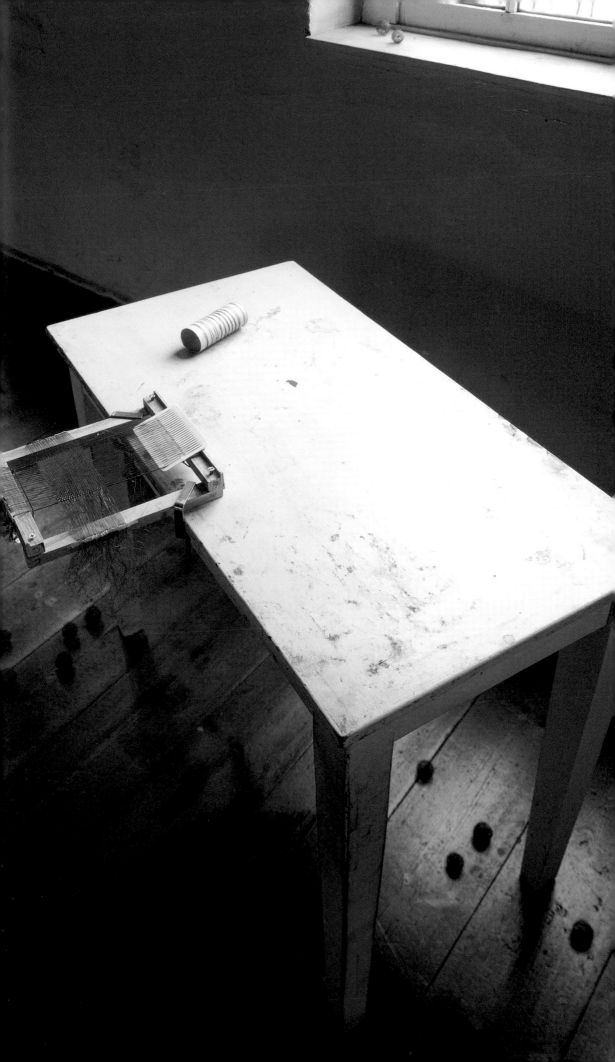

Present Tense (Tempo presente), 1996,
sapone, perle di vetro,
4,5 x 299 x 241 cm (particolare)
soap, glass beads, 1¾ x 117 x 95" (detail)

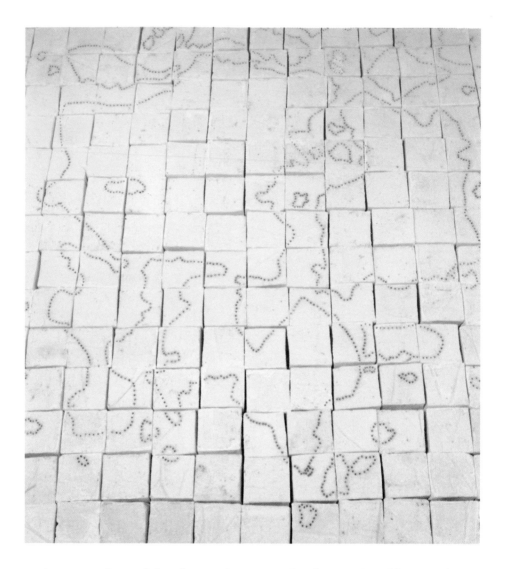

za al contesto, che condiziona la percezione dell'opera e perciò il suo significato. L'artista adotta un linguaggio formale per restituirlo al contesto dei rapporti di potere agiti nella società dalla quale è stato originato, come nel caso della griglia, emblema modernista per eccellenza.

La griglia, cioè l'intersecarsi ortogonale di linee rette o di piani, compare nella costruzione delle due versioni di *Quarters (Alloggi)*, 1966, torri metalliche in tutto simili a letti a castello ridotti alla pura armatura. Nella versione maggiore, realizzata per una mostra nello spazio di Viafarini a Milano, il gran numero di

struction of two versions of Quarters *(1996), where metal towers, similar to loft beds, are reduced to pure armature. In the larger version, created for an exhibition at Viafarini in Milan, the large number of elements shown increases their allusiveness to beds in barracks, prisons or dormitories, settings intended for confinement or for the temporary accommodation of unwanted guests. In other cases a work may take the context in which it is located as its central theme. This was the case with Hatoum's 1996 exhibition at the Anadiel gallery, in the Arab part of Jerusalem. In one of the works exhibited,* Present Tense, *small white cubes of soap were arranged in a grid*

Present Tense (*Tempo presente*), 1996,
sapone, perle di vetro, 4,5 x 299 x 241 cm
soap, glass beads, 1¾ x 117 x 95"
Installazione/installation, Anadiel Gallery, Jerusalem

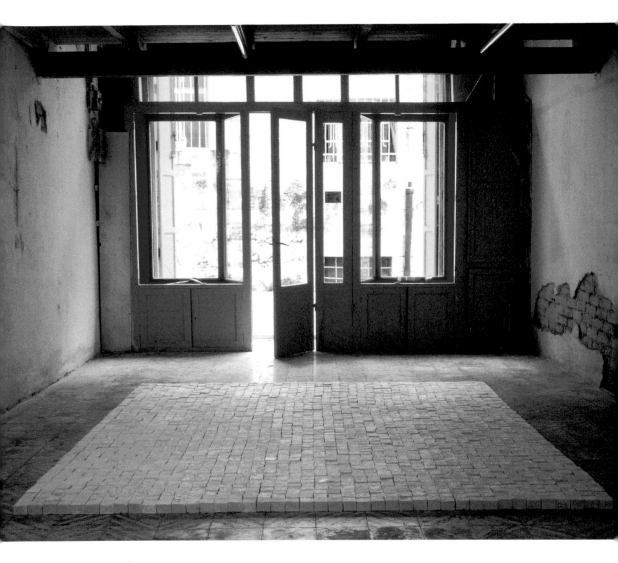

esemplari esposti accresce la loro allusività ai letti delle caserme o delle carceri, ai dormitori, ad ambienti atti alla reclusione o alla provvisoria sistemazione di ospiti non desiderati. In altre occasioni, l'opera tematizza il contesto in cui viene a collocarsi. È il caso della mostra che Hatoum ha tenuto nel 1996 presso la galleria Anadiel, posta nella parte araba di Gerusalemme. Tra le opere esposte, *Present Tense* (*Tempo presente*) indica un insieme di piccoli cubi bianchi accostati fino a formare un ampio quadrato posto a pavimento. Sulla superficie del quadrato un gran numero di perline di vetro disegna quelle che a prima

that formed a large square on the floor. A pattern of glass beads had been embedded into the surface of the soap and appeared at first glance to be an arrangement of abstract shapes. The cubes were actually bars of olive oil soap still made by hand in Nablus following a traditional process in use for over a century. The glass beads, in fact, represented the boundaries of the Palestinian State as hypothesised by the Oslo Accord. The resulting "map" shows fragmented parcels of land without any territorial integrity or apparent connection.
For the artist, the juxtaposition of an element linked to the historical identity of her people and the affirmation of the impossibility of

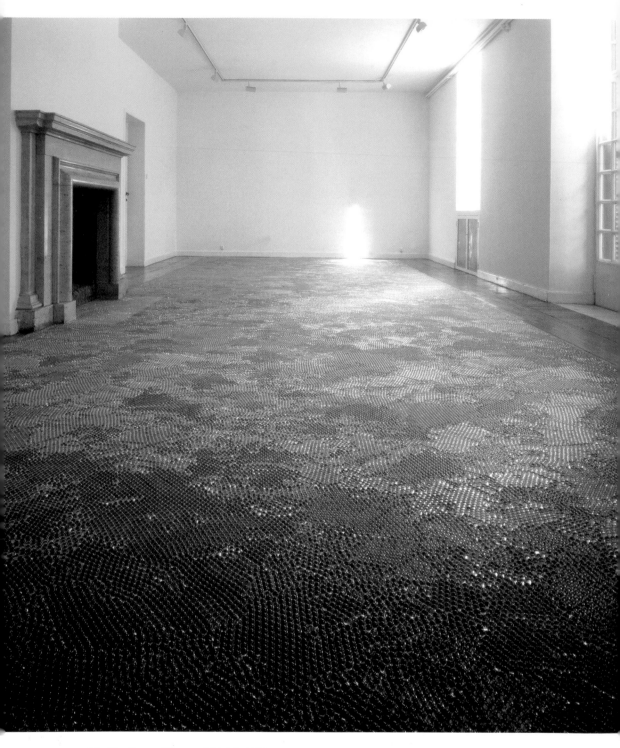

Marbles Carpet (*Tappeto di biglie*), 1995,
biglie in vetro, 1,5 x 340 x 1100 cm
glass marbles, ½ x 134 x 433½
Installazione/installation, British School at Rome, Roma

Map (Mappa), 1998, ▶
biglie in vetro, dimensioni determinate
dall'ambiente (particolare)
glass marbles, dimensions determined
by the space (detail)

vista sembrano forme astratte. I cubi sono in realtà saponi di Nablus realizzati secondo un antico procedimento tutt'ora in uso e tipico di quella città, e le perle di vetro disegnano i confini dello stato palestinese così come è stato ipotizzato dal trattato di Oslo, cioè come un insieme di zone incomunicabili l'una con l'altra. Per l'artista, l'accostamento fra un elemento che riconduce all'identità storica del suo popolo e la constatazione della sua impossibile autodeterminazione oggi e nell'immediato futuro vale come un segno di resistenza. Un'altra opera non risulta meno emblematica: *Lili (stay) put (Lili - stai- ferma)* è costituita da un vecchio letto a cui l'artista ha aggiunto quattro rotelle, ma che ha poi trattenuto al suolo tramite innumerevoli fili da pescatore (come Gulliver a Lilliput, appunto), alludendo così ad uno stato di blocco e costrizione.

Un'altra importante strategia con la quale Hatoum ricorre alla lezione formale minimalista per rovesciarne le premesse è il confronto che spesso attua fra la semplice evidenza strutturale delle forme che elabora e l'aspetto organico e per questo vagamente respingente del materiale che impiega. È il caso di *Socle du Monde (Piedestallo del mondo)*, del 1992-93, col quale l'artista cita l'opera di Piero Manzoni che nel 1961 designa come opera d'arte l'intero globo terrestre e ne costruisce il piedistallo, che espone coerentemente all'aperto e rovesciato. Chiamata a partecipare ad una mostra collettiva in Canada, l'artista propone ancora un mondo reso opera d'arte, ma che ora riposa su un piedistallo corroso, come colpito da qualche malattia che ne mina la consistenza e la stabilità. L'effetto dell'erosione è dato dall'applicazione di una grande quantità di limatura di ferro applicata su superfici di metallo grazie all'im-

their self-determination, at present or in the immediate future, takes on the value of a sign of resistance. Another piece is equally emblematic: Lili (stay) put *consisted of an old bed frame to which the artist added four wheels. She then contradicted the possibility of movement by tying the frame to the floor with innumerable fishing wires (like Gulliver in Lilliput), therefore alluding to the tension between displacement and rootedness. Hatoum resorts to the formal lessons of Minimalism in order to overturn its premises through another important strategy. Frequently, she confronts the simple structural evidence of the forms she devises with the organic and vaguely repellent aspects of the material she uses. In* Socle du Monde, 1992-93, *the artist quotes the work of Piero Manzoni. In 1961, Manzoni used the entire terrestrial globe as a work of art and constructed a pedestal for it, which he exhibited outdoors, upside down. Invited to participate in a group exhibition in Canada the artist proposed another world-turned-into-artwork, but which rested on a base that was corroded, as if struck by some disease that undermined its consistency and stability. The effect of the erosion was obtained by the application of a large quantity of iron filings, applied to the metal surface with magnets. The arrangement of the filings took on a contorted configuration that brought to mind the convolutions of a massive, black brain. The same principle governs* Entrails Carpet (1995), *a silicone carpet where the surface seems interwoven with intestine-like curves. The relationship between sensually repellent content and its encasement in an ascetic and precise form is the principal motif for* Corps étranger (1994), *perhaps Hatoum's most well known installation, shown at the 1995 Venice Biennale. A tall circular structure had two door openings that allowed the public to enter and observe a screen—also circular, placed on the floor—showing a video made using a med-*

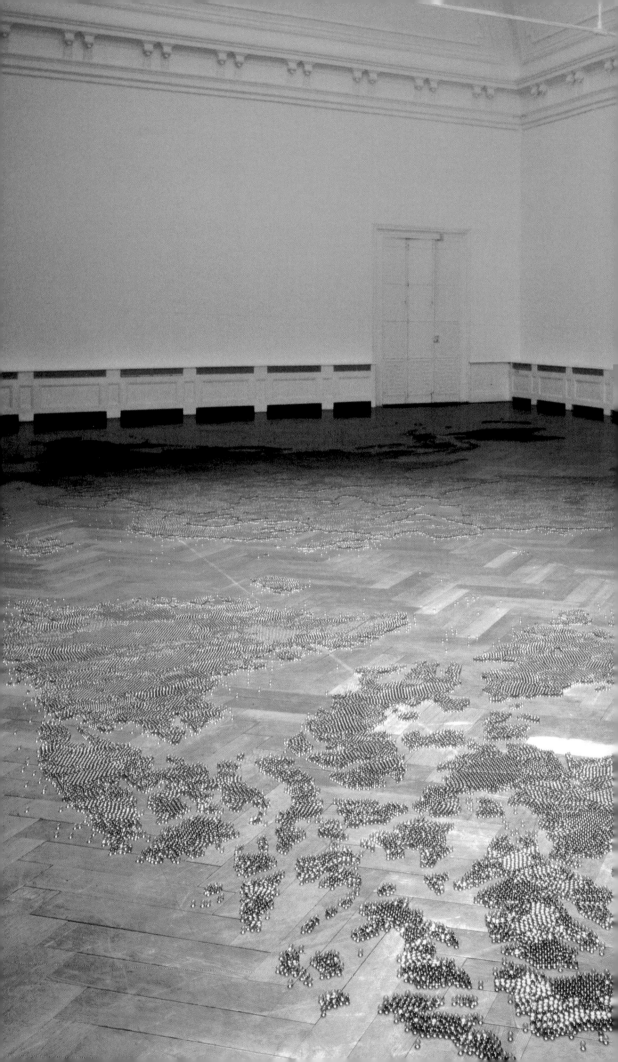

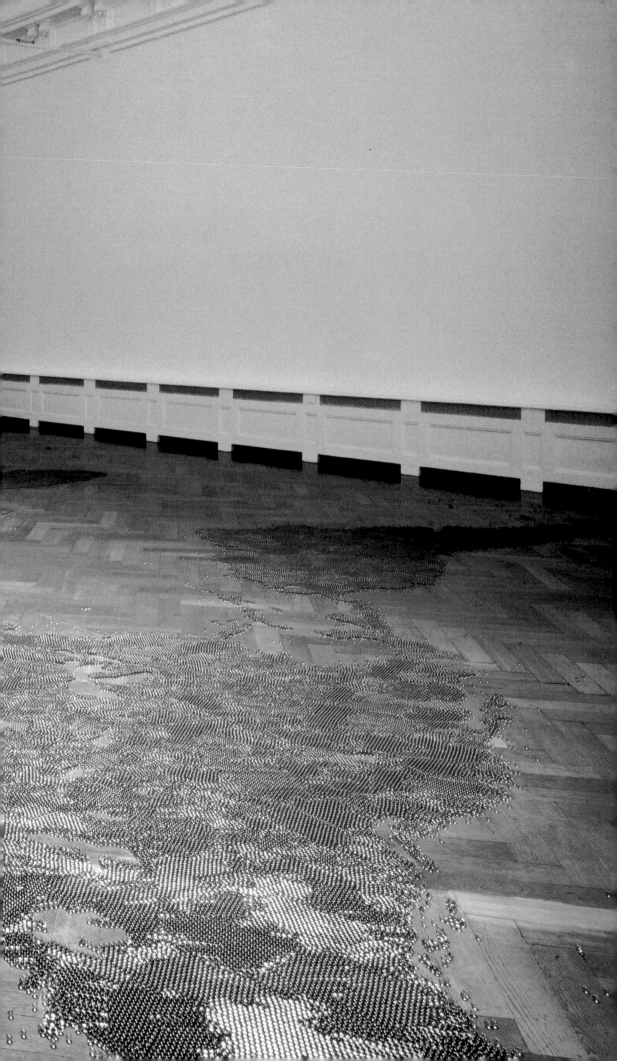

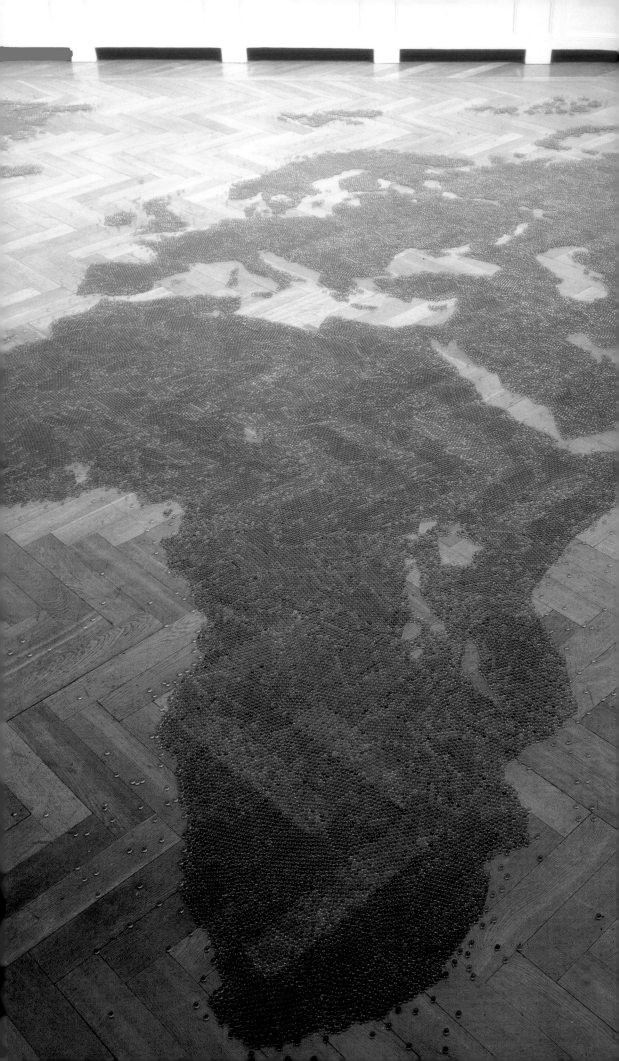

Map (Mappa), 1998,
biglie in vetro, dimensioni
determinate dall'ambiente (particolare)
glass marbles, dimensions determined
by the space (detail)

piego di calamite; la sua disposizione prende un'andatura contorta che fa pensare alle circonvoluzioni di un ciclopico e nero cervello. Lo stesso principio governa *Entrails Carpet (Tappeto di visceri)*, 1995, un tappeto in silicone la cui superficie sembra intessuta dalle volute di un abnorme intestino. Il rapporto fra un contenuto sensualmente respingente e una messa in forma asettica e accurata è poi il motivo principale di *Corps étranger (Corpo estraneo)*, 1994, forse l'installazione più famosa di Hatoum, presentata anche alla Biennale di Venezia del 1995. Si tratta di un'alta struttura circolare provvista di due aperture che consentono al pubblico di porsi all'interno e di osservare attraverso uno schermo anch'esso circolare posto a terra la proiezione del viaggio compiuto da una sonda per endoscopie lungo le superfici del corpo dell'artista e poi al suo interno, valicando il limite dei suoi orifizi e mostrando l'interno dei visceri.

L'elevazione verticale della struttura, che sembra una sorta di mausoleo, si contrappone alla collocazione a terra della proiezione, e sembra voler sublimare l'effetto un po' rivoltante della visione dall'interno degli organi del corpo. Attirato verso il basso, verso la cavità su cui si sporge come un baratro risucchiante, lo spettatore viene messo a confronto non solo con lo sguardo della sonda, sguardo medico e terapeutico per quanto impietoso, ma anche con l'attrazione ambivalente per lo spettacolo di una visceralità beante, e segnatamente femminile, sufficientemente esplicita da richiamare i consueti fantasmi psicanalitici. Il femminile come disturbo viene sperimentato anche con operazioni quali *Jardin public (Giardino pubblico)*, 1993, dove un triangolo di peli pubici emerge dai fori applicati al metallo di una sedia da giardino, e nella più complessa installazio-

ical, endoscopic camera. The video first explores the surface of the artist's body and then penetrates and moves through her orifices to reveal the viscerality of the inside of the body. The vertical elevation of the structure, which seems like a sort of mausoleum, was opposed to the floor placement of the projection, and seemed designed to sublimate the somewhat revolting effect of the view of the interior of the body's organs. Drawn down toward the cavity that pulled them in like some devouring abyss, viewers were confronted not only with the view seen from the endoscope, a medical and therapeutic, if merciless, view, but also with their ambivalent attraction to the spectacle of a gaping and markedly female viscerality, sufficiently explicit to bring to mind the usual psychoanalytical fantasies.

The female as disturbance is also investigated in works such as Jardin public *(1993), where a triangle of pubic hair emerges from holes in the seat of a metal garden chair, and in a more complex installation,* Recollection *(1995), conceived specifically for the Beguinage St. Elizabeth in Kortrijk, Belgium, where Hatoum worked as an artist-in-residence.*

Invited to exhibit in the space of the former convent, the artist decided to use a material that refers directly to femininity, and once again she turned to her own body. The viewer entered an apparently empty room, where, with difficulty, he or she could glimpse numerous small balls scattered on the floor, a small loom on a table, and a few other elements. All the pieces were created from the artist's hair, patiently collected by her over a period of more than six years, and, until that occasion, saved in several shoe boxes. Rolled up into small balls and thrown on the ground, or stretched on the loom in place of yarn, bearing witness to a traditional women's activity, the hair was used to contextualize a place and a social role, and at the same time to disturb one's perception of the actual space. Strands of single hairs hung in

Untitled (Wheelchair) (Senza titolo - Sedia a rotelle), 1998, ▶
acciaio inossidabile, gomma, 97 x 50 x 84 cm
stainless steel, rubber, 38 x 19¾ x 33"

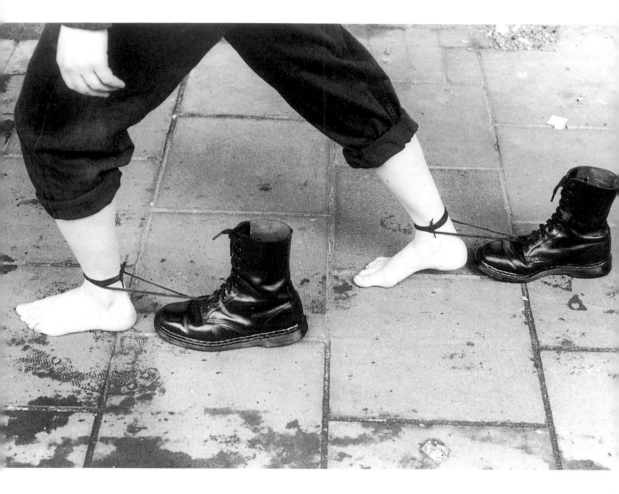

Roadworks (Lavori per strada), 1985,
performance, Brixton - London

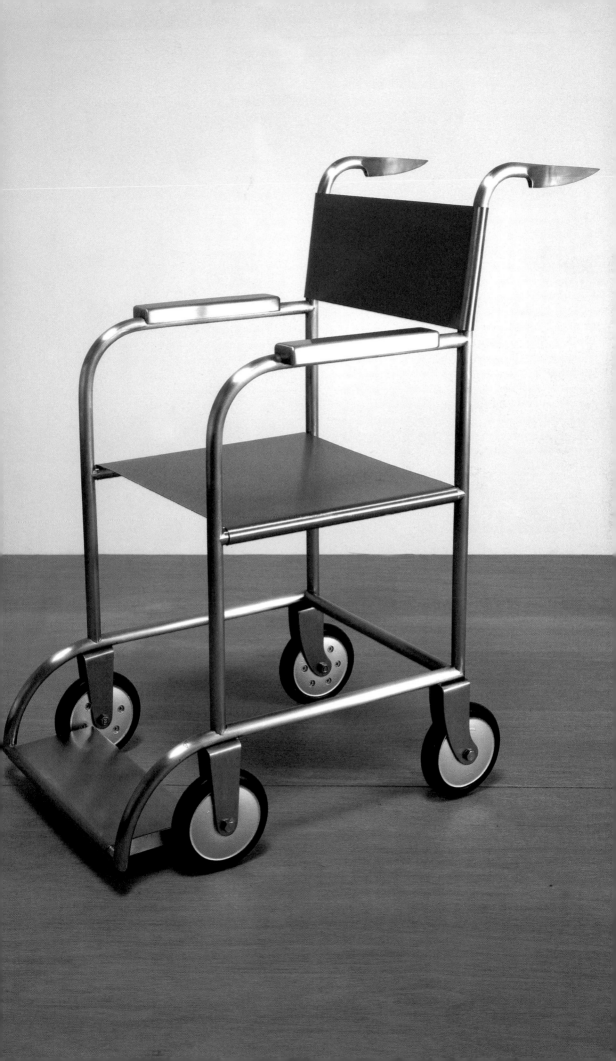

Biografia

Biography

Nata a Beirut nel 1952, Mona Hatoum ha studiato presso il Beirut University College fra il 1970 e il 1972. Lo scoppio della guerra civile in Libano, avvenuto durante un suo viaggio a Londra, le impedisce il ritorno in patria. Resta dunque in Gran Bretagna dove si dedica agli studi artistici all'estero. A Londra si diploma prima alla Byam Shaw Art School of Art nel 1979 e in seguito alla Slade School of Art nel 1981.

Dal 1983 tiene mostre personali, costituite da una performance, presso luoghi espositivi quali The Western Front a Vancouver (1983), The Franklin Furnace e ABC No Rio a New York (1984), The Orchad Gallery a Derry (1985).

Dal 1984 ottiene le prime borse di studio ("Artist in residence") che le consentono di lavorare ed esporre in rassegne personali e collettive a Vancouver (1984), a Seattle (1985) a Londra (1986) e in altre città.

Dalla fine degli anni Ottanta il suo interesse si rivolge all'installazione, la cui prima formulazione è l'opera *The Light at the End*, presentata per la prima volta a The Showroom a Londra nel 1989. Proprio le installazioni impongono il suo lavoro alla considerazione di critica e pubblico, e permettono all'artista di partecipare ad importanti rassegne, spesso itineranti, quali *The British Art Show* alla Hayward Gallery di Londra, *Passages de l'Image* al Centre Georges Pompidou di Parigi (1990); la quarta edizione della Biennale dell'Avana, *Shock to the System* al Royal Festival Hall e *The Interrupted Life* al New Museum of Contemporary Art di New York (1991); *Pour la suite du Monde* al Musée d'Art Contemporain di Montréal (1992); *Four Rooms* alla Serpentine Gallery di Londra (1993); *Sense and Sensibility* al Museum of Modern Art di New York e *Cocido y*

Born in Beirut in 1952, Mona Hatoum studied at Beirut University College from 1970 to 1972. While on a short visit to London, the outbreak of the civil war in Lebanon prevented her returning home. She remained in Great Britain and consequently she attended art school in London graduating first from the Byam Shaw School of Art in 1979 then the Slade School of Art 1981.

Since 1983 she had a number of solo performance exhibitions such as The Western Front in Vancouver (1983), Franklin Furnace and ABC No Rio in New York (1984) and the Orchad Gallery in Derry (1985). From in 1984 she was invited to be "Artist in Residence" in a number of art centers resulting in solo exhibitions in Vancouver (1984), Seattle (1985), London (1986) and other cities.

By the late 1980s Hatoum's work began to shift towards installation, the first of which is The Light at the End conceived for The Showroom in London where it was first shown in 1989.

This brought her work to the attention of both critics and the public, which led to the work being included in important survey shows, many of which traveled, such as The British Art Show at the Hayward Gallery in London, Passages de l'Image at the Centre Georges Pompidou in Paris (1990); the fourth Havana Biennial, Shock to the System at the Royal Festival Hall, London, and The Interrupted Life at The New Museum of Contemporary Art in New York (1991); Pour la suite du Monde at the Musèe d'Art Contemporain in Montreal (1992); Four Rooms at the Serpentine Gallery in London (1993); Sense and Sensibility at the Museum of Modern Art in New York and Cocido y Crudo at the Centro de Arte Reina Sofia in Madrid (1994).

Hatoum's work was the subject of solo exhibitions at Chapter Art Center in Cardiff, Wales, 1992, and at the Arnolfini Gallery in Bristol, England, 1993. In 1994 she was

Crudo al Centro de Arte Reina Sofia di Madrid (1994).

Tiene mostre personali presso il Chapter Art Centre di Cardiff nel 1992 e la Arnolfini Gallery di Bristol nel 1993. Nel 1994 viene invitata dal Centre Georges Pompidou di Parigi a realizzare la video-installazione *Corps étranger* poi esposta nell'ambito di una personale nello stesso museo.

Dalla metà degli anni Novanta Mona Hatoum viene indicata come una delle figure più significative nel panorama artistico internazionale. Nel 1995 viene segnalata per il Turner Prize, partecipa alla Biennale di Venezia e a quella di Istanbul così come ad altre mostre collettive quali *ARS 95* alla Finnish National Gallery a Helsinki e *Rites of Passage* alla Tate Gallery di Londra. Nel 1996 realizza una serie di importanti installazioni in vista di mostre personali quali *Current Disturbance* al Capp Street Project a San Francisco, *Present Tense* alla Anadiel Gallery a Gerusalemme e *Quarters* nello spazio di Viafarini a Milano. Una mostra antologica le viene organizzata dal Museum of Contemporary Art di Chicago nel 1997, per poi toccare le sedi del New Museum of Contemporary Art di New York, il Museum of Modern Art di Oxford e lo Scottish National Gallery of Modern Art di Edimburgo nel 1998, anno in cui tiene inoltre una personale alla Kunsthalle di Basilea.

Dal 1986 al 1997 ha insegnato al Central Saint Martins School of Art di Londra, alla Jan van Eyck Akademie di Maastricht, all'Ecole Nationale Supérieure des Beaux-Arts di Parigi. Dal 1989 al 1992 è stata Senior Fellow in Fine Arts al Cardiff Institute of Higher Education.

Mona Hatoum vive e lavora a Londra.

invited by the Centre Georges Pompidou to produce the video installation Corps étranger which became the focus of her solo show held at the same museum in the same year.

Since the mid-90s Hatoum has emerged as one of most significant figures in the International art world. In 1995 she was short listed for the Turner Prize in London, she participated in the Venice Biennale and the Istanbul Biennial, and took part in numerous museum group shows, including ARS 95 at the Finnish National Gallery in Helsinki and Rites of Passage at the Tate Gallery in London.

In 1996 she created a number of large and significant installations for her solo exhibitions such as Current Disturbance for Capp Street Project in San Francisco, Present Tense for Anadiel Gallery in Jerusalem and Quarters for Viafarini in Milan. A large survey exhibition of her work was organized by the Museum of Contemporary Art in Chicago in 1997 and traveled to the New Museum of Contemporary Art in New York, the Museum of Modern Art in Oxford and the Scottish National Gallery of Modern Art in Edinburgh until 1998, when she also had a solo exhibition at the Kunsthalle in Basel.

From 1986 to 1997 she taught at Central Saint Martins School of Art in London, at the Jan van Eyck Akademie in Maastricht, at L' Ecole National Superieure des Beaux-Arts in Paris. From 1989 till 1992 she held the post of Senior Fellow in Fine Art at the Cardiff Institute of Higher Education in Wales.

Mona Hatoum lives and works in London.

Mostre personali
One Person Exhibitions

1981
Look No Body!, Basement Gallery, Newcastle-upon-Tyne.

1983
The Negotiating Table, Saw Gallery, Ottawa; N.A.C., St. Catherines, Canada; The Western front, Vancouver.

1984
The Negotiating Table, Franklin Furnace, New York.
Variation on Discord and Divisions, ABC No Rio, New York; A.K.A., Saskatoon, Canada; The Western Front, Vancouver; Articule, Montréal.

1985
Between the Lines, Orchard Gallery, Derry.

1987
9.1.1. Contemporary Art Centre, Seattle.
Hidden from Prying Eyes, Air Gallery, London.

1989
The Light at the End, The Showroom, London; Oboro Gallery, Montréal.

1992
Mario Flecha Gallery, London.
Dissected Space, Chapter, Cardiff, cat. testo/text G. Brett.

1993
Mona Hatoum: Recent Work, Arnolfini, Bristol, cat. testi/texts G. Brett, D. Philippi.
South London Gallery, London, (con/with Andrea Fisher), cat. testi/texts D. Thorp, T. Dent.
Positionings/Transpositions (con/with Barbara Steinman), Art Gallery of Ontario, Toronto, cat. testo/text M. Thèriault.
Socle du Monde, Galerie Chantal Crousel, Paris.

1994
Galerie René Blouin, Montréal.
Musée national d'art moderne Centre Georges Pompidou, Paris, cat. testi/texts J. Lageira, D. Philippi, N.Tazi, C. van Assche.
You Are Still Here, C.R.G. Art Incorporated, New York.

1995
White Cube, London.
Kunststichting Kanaal Art Foundation, Kortrijk - Belgium.
Short Space, Galerie Chantal Crousel, Paris.
The British School at Rome, Roma, cat. testo/text M. Archer.

1996
The Fabric Workshop and Museum, Philadelphia.
Anadiel Gallery, Jerusalem.
Current Disturbance, Capp Street Project, San Francisco, cat. testo/text M. Ceruti.
Quarters, Viafarini, Milano, cat. testo/text A. Vettese.
De Appel, Amsterdam, cat. testo/text D. Pieters.

1997
Museum of Contemporary Art , Chicago; The New Museum of Contemporary Art, New York; Museum of Modern Art, Oxford e/and the Scottish National Gallery of Modern Art, Edinburgh (1998), cat. testi/texts D. Cameron, J. Morgan.
Galerie René Blouin, Montréal.

1998
Kunsthalle,Basel, cat. testi/texts B. Fer, M. Schuppli.

Mostre collettive selezionate
Selected Group Exhibitions

1989
Intimate Distance, The Photographers' Gallery, London, cat. testi/texts A. Lord, G. Tawadros
The Other Story, Hayward Gallery, London ; Wolverhampton Art Gallery, Wolverhampton; Manchester City Art Gallery at Conerhouse, Manchester, cat. testi/texts R. Araeen et al.

1990
The British Art Show, McLellan Galleries, Glasgow ; Leeds City Art Gallery and Hayward Gallery, London, cat. testi/texts C. Collier, A. Naime, D. Ward.
Passages de l'image, Musée national d'art moderne Centre Georges Pompidou, Paris; Fundacio Caixa de Pensions, Barcelona; Power Plant, Toronto; Wexner Arts Center, Columbus; Modern Art Museum, San Francisco, cat. testi/texts P. Bonitzer, C. David et al.
Video and Myth, The Museum of Modern Art, New York.

1991
IV Bienal de la Habana, La Habana, Cuba, cat. testo/text L. Llanes.
Shocks to the System, Royal Festival Hall, London; Northern Center for Contemporary Art, Sunderland; Ikon Gallery, Birmingham; Towner Art Gallery, Eastbourne; Royal Albert Memorial Museum, Exeter; City Museum and Art Gallery, Plymouth; Maclaurin Art Gallery,

Ayr, cat. testo/text N. Ascherson.
The Interrupted Life, The New Museum of
Contemporary Art, New York, cat. testi/texts
S. Lotringer et al.

1992
Pour la Suite du Monde, Musée d'Art
Contemporain de Montréal, cat. testi/texts
D. Crimp, F. Guattari, T. Hensch et al.
*Manifeste, 30 ans de création en perspective 1960-
1990*, Musée national d'art moderne Centre
Georges Pompidou, Paris.

1993
Four Rooms, Serpentine Gallery, London, cat.
testo/texts J. Roberts.
Eros, c'est la vie, Le Confort Moderne, Poitiers,
cat. testo/text D. Truco.

1994
Forces of Change. Artists of the Arab World,
The National Museum of Women in the Arts,
Washington D.C., cat. testi/texts E. Adnan et al.
Le Saut dans le vide, TSDKH-Exhibition Centre,
Moskva.
Espacios Fragmentados, V Bienal de la Habana,
Centro Wifredo Lam, La Habana, cat.
testi/texts G. Brett, L. Llanes, E, Valdés
Figueroa.
*Sense and Sensibility. Women and Minimalism in
the Nineties*, Museum of Modern Art, New York,
cat. testo/text L. Zelevansky.
Cocido y Crudo, Museo Nacional Centro de Arte
Reina Sofia, Madrid, cat. testi/texts
D. Cameron, J. Fischer, G. Mosquera, J. Saltz,
M. Villaespesa.

1995
Identità e Alterità.Figure del corpo 1895/1995, XLVI
Esposizione Internazionale d'Arte La Biennale di
Venezia, Venezia, cat. testo/text J. Clair.
Rites of Passage, Tate Gallery, London, cat.
testi/texts S. Morgan, F. Morris.
Femininmasculin. Le sexe de l'art, Musée national
d'art moderne Centre Georges Pompidou,
Paris, cat. testi/texts M.-L. Bernadac,
B. Marcadè.
The Turner Prize 1995 exhibition, Tate Gallery,
London, cat. testi/text V. Button, W. Januszczak,
N. Serota.
Orient/ation, 4th International Istanbul Biennial,
Istanbul, cat. testo/text N. Fulya Erdemci.

1996
Inside the Visible, Institute of Contemporary Art,
Boston; The National Museum of Women in
the Arts, Washington; Whitechapel Art Gallery,
London; Art Gallery of Western Australia, Perth

(1997), cat. testi/texts C. de Zegher,
D. Philippi et al.
NowHere, Louisiana Museum of Modern Art,
Humlebaek, Copenhagen, cat. testi/texts
B. Ferguson et al.
Fremdkörper/ Corps étranger/ Foreign Body,
Museum für Gegenwartskunst, Basel, cat.
testo/text T. Vischer.
*Distemper. Dissonant Themes in the Art of the
1990s*, Hirshhorn Museum and Sculpture
Garden, Washington, cat. testi/texts
N. Benezra, O.M. Viso.
*Life/Live.La scène artistique au Royaume-Uni en
1996, des nouvelles aventures*, Musée d'Art
Moderne de la Ville de Paris, Paris; Centro
Cultural de Belèm, Lisboa, cat. testi/texts M.
Archer, L. Bossè, H.-U. Obrist.

1997
De-Genderism: détruire, dit-elle/il,Setagaya Art
Museum, Tokyo, cat, testi/texts D. Elliott, Y.
Hasegawa, Y. Kobayashi, N. Sawaragi, R. Storr.
Artistes Palestiniens contemporains, Institut du
Monde Arabe, Paris, cat. testi/text G. Brett et al.
Kwangju Biennale, Chogno-ku, South Korea,
cat. testi/texts L. Young.Chul, P. Virilio et al.
Sensation, Royal Academy of Arts, London;
Hamburger Banhof, Berlin (1998), cat.
testi/texts B. Adams, M. Maloney, R. Shone et al.
Trash. Quando i rifiuti diventano arte, Palazzo
delle Albere, Trento, cat. testi/texts R. Ghezzi,
L. Vergine et al.
Art from the UK, Sammlung Goetz,München,
cat., intervista all'artista di/interview with the
artist M. Archer.

1998
*Wounds. Between Democracy and Redemption in
Contemporary Art*, Moderna Museet, Stockholm,
cat. testi/texts M. Collis, D. Elliot, P.L. Tazzi et al.
Close Echoes, Public Body & Artificial Eye: City Art
Gallery, Prague, Kunsthalle, Krems, cat.
testi/texts O. Malà, D. Mussgrave et al.
Echolot, Museum Fridericianum, Kassel, cat.
testo/text M. Archer sull'artista/on the artist
Real/Life. New British Art, Tochigi Prefectural
Museum of Fine Arts; Fukuoka City Art
Museum; Hiroshima City Museum of
Contemporary Art; Tokyo Museum of
Contemporary Art; Ashiya City Museum of Art
History (1999), cat. testi/texts J. Roberts, A. Rose.
Traversées/Crossings, National Gallery of
Canada, Ottawa, cat. testi/texts H. Hanru,
D. Nimeroff, N. Papastergiadis.
*Emotion. Young British and American Artists from
the Goetz Collection*, Deichtorhallen, Hamburg,
cat. testi/texts I. Blazwick, Y. Dziewior,
C. Freedman et al.

Bibliografia selezionata
Selected Bibliography

Monografie sull'artista/Monographs on the artist
M. Archer - G. Brett - C. de Zegher, *Mona Hatoum*, Phaidon Press, London, 1997.

Quotidiani e periodici/Newspapers and Magazines

1980
J. Roberts, *Five Days at Battersea Arts Centre*, in "Art Monthly", London, maggio/May, 1980.

1981
C. Elwes, *Notes from a Video Performance by Mona Hatoum*, in "Undercut", London, marzo-aprile/March-April.

1984
D. Briers, *Highlands and Deserts: A performance Pilgrimage*, in "Performance", London, settembre-ottobre/September-October .

1985
R. Lee, *Mona Hatoum*, in "Parallelogramme", Toronto, aprile-maggio/April-May.
G. Brett, "Roadworks" at Brixton Art Gallery, in "Artscribe", London, luglio-agosto/July-August.
P. Rigby Watson, *Mona Hatoum*, in "Vanguard", Vancouver, marzo/March .
G. Pevere, *Collision in the Capital*, in "Fuse", Toronto, estate/Summer.
P. D. Burwell, *Hostile Realities*, in "High Performance", n. 2, Los Angeles.

1987
S. Diamond, *An Interview with Mona Hatoum*, in "Fuse", Toronto, aprile/April 1987.
G. Brett, *Experiment or Institutionalisation*, in "Performance", London, maggio-giugno/May-June.
S. Rogers, *The National Review of Live Art*, in "Performance", London, novembre-gennaio 1988/November-January 1988

1988
M. Christakos, *Identity and Resistance*, in "Fuse", Toronto, luglio/July.
S. Bode, *Measures of Distance*, in "City Limits", London, 14-21 luglio/July.
S. Biggs, *Video and Architecture*, in "Mediamatic", Amsterdam, giugno/June.
S. Durland, *Throwing a Hot Coal in a Bathtub: London's Edge 88*, in "High Performance", Los Angeles, inverno/Winter.

1989
O. Bennet, *British Performance on the EDGE*, in " The New Art Examiner", Chicago, febbraio/February.
S. Wakely, *Mona Hatoum: Showroom*, in "Time Out", London, 19 luglio/ July.
J. Stathatos, *Mona Hatoum*, in "Art Monthly", London, settembre/September .
J. Watkins, *World Chronicle: Odd forms in everyday places*, in "Art International", inverno/ .
G. Brett, *Mona Hatoum at the Showroom*, in "Art in America", New York, novembre/November.

1990
D. Philippi, *Mona Hatoum, The Witness Beside Herself*, in "Parachute", Montréal, aprile-giugno/April-June.
P. Usherwood, *TSWA: Newcastle*,in "Art Monthly", London, novembre/November.

1991
R. Smith, *The Faces of Death*, in "The New York Times", New York, 13 settembre/September.

1992
C. Pontbriand, *Pour la Suite du Monde*, in "Parachute", Montréal, ottobre-dicembre/October-December.
R. Jennings, *Mona Hatoum*, in "Time Out", London, 4-11 novembre/November.
M. Archer, *Mona Hatoum*, in "Artforum", New York, dicembre/December.
C. Rendell, *Mona Hatoum: New Installations, 1990-92*, in "Arts Review", London, dicembre/December.

1993
C. Faure Walker, *Mona Hatoum*, in "Art Monthly", London, marzo/March .
D. Cameron, *Mona Hatoum*, in "Artforum", New York, aprile/April.
W. Feaver, *Inner Space Terrors*, in "The Observer", London, 16 maggio/May.
L. MacRichie, *Uncomfortable Installations*, in "Financial Times", London, 21 maggio/May.
B. Hatton, *Umspace*, in "Art Monthly", London, giugno/June.
R. Baert, *Desiring Daughters*, in "Screen", London, estate/Summer .
C. Smith, *Lights Out*, in "Women's Art Magazine", London, luglio-agosto/July-August.
L. MacRitchie, *Uneasy Rooms*, in "Art in America", New York, ottobre/October.
L. Louppe, *Mona Hatoum*, in "Art Press", Paris, dicembre/December.

1994
M. Agassi, *Mona Hatoum*, in "Studio Magazine", Tel Aviv, giugno-luglio/June-July.
C. Tougas, *Mona Hatoum*, in "Parachute",

Montréal, luglio-settembre/July-Septembre.
E. Lebovici, *Mona Hatoum, intérieur nuit*, in
"Liberation", Paris, 2-3 luglio/July.
E. Hess, *Minimal Women*, in "The Village
Voice", New York, 5 luglio/July.
J. Drucker, *Sense and Sensibility*,in "Third Text",
London, estate/Summer.
L. Berger, *Mona Hatoum In Between, Outside &
in the Margins*, in "Art News", New York, set-
tembre/September.
Y. Abrioux - S. Grant, *Mona Hatoum at the
Pompidou: Two Responses*, in "Untitled", London,
autunno/Autumn.
F. Collin, *Mona Hatoum, Voiles et grillages*, in
"Blocnotes", Paris, autunno/Autumn.
P. Brignone, *Mona Hatoum*, in "Art Press",
Paris, ottobre/October.
E. Heartney, *Sens et sensibilité, Sense and
Sensibility*,in " Art Press", Paris, ottobre/.
R. Smith, *Three who know political conflict*, "The
New York Times", New York, 11
novembre/November.
M. Lind, *Mona Hatoum's State of Emergency*, in
"Paletten", n. 219, Göteborg.

1995
M. Mariño, *Mona Hatoum at CRG*, in "Art in
America", New York, gennaio/January.
N. Miyamura, *Interview with Mona Hatoum*, in
"BT Magazine", Tokyo, gennaio/January.
L. Anson, *Mona Hatoum*,in "Art Monthly",
London, marzo/March.
M. Akar, *Un exil apprivoisé*, in "Qantara", Paris,
aprile-giugno/April-June.
A. Kingston, *Mona Hatoum*, in "Flash Art
International", Milano, aprile/April.
M. Macdonald, *The Inside Story*, in "The
Independent on Sunday", London, 27
agosto/August.
K. Deepwell, *Inside Mona Hatoum*, in "Tate
Gallery Magazine", London, estate/Summer.
T. Macri', *Mona Hatoum*,in "Virus", Milano,
ottobre/October.

1996
L. Cherubini, *Mona Hatoum*, in "Flash Art",
Milano, febbraio-marzo/February-March.
B. Arning, *Two Serious Ladies*, in "The Village
Voice", New York, 9 april/April.
C. Ross, *To Touch the Other: A Story of Corpo-elec-
tronic Surfaces*, in "Public", no. 13, Toronto.
C. Spinelli, *Interview with Mona Hatoum*, in
"Das Kunst-Bulletin", Zürich,
settembre/September.
S. Shapira, *Mona Hatoum*, in "Flash Art
International", Milano, ottobre/October.
K. Baker, *San Francisco: Mona Hatoum*, in
"ArtNews", New York, dicembre/December.

T. Casapietra, *Mona Hatoum*, in "Flash Art",
Milano, dicembre-gennaio 1997/December-
January. 1997

1997
H. Cotter, *Pangs of Exile and Lost Childhood*, in
"The New York Times", New York, 5 dicem-
bre/December.
H. Halle, *Perfect stranger*, in "Time Out", New
York, 18-25 dicembre/December.

1998
M. Grabner, *Positive and Negative*, in "Frieze",
London, gennaio-febbraio/January - February.
P. Masterson, *Bodily observations*, in "Tate
Magazine", London, primavera/Spring.
J. Antoni, *Mona Hatoum*, in "Bomb", New York,
primavera/Spring.
N. Israel, Nico, *Mona Hatoum*, in "Artforum",
New York, aprile/April.
W. Feaver, *Mona Hatoum*, in "The Observer",
London, 12 aprile/April.
S. Kent, *Creature discomforts. Mona Hatoum deals
with displacement*, in "Time Out", London, 15
aprile/April 1998.
T. Garb, *Mona Hatoum*, in "Art Monthly",
London, maggio/May.
S. Herzog, *Mona Hatoum*, in "Kunst-Bulletin",
Zürich, luglio-agosto/July-August
A. Dimitrakaki, *Mona Hatoum: a Shock of a
Different Kind*, in "Third Text", London, esta-
te/Summer.
E.J.Dickinson, *Body of Work*, in "The
Independent Sunday Magazine", London, 1
agosto/August.
P. Harper, *Visceral geometry*, in "Art in America",
New York, settembre/September.

Finito di stampare nel mese di marzo 1999
da Leva spa, Sesto San Giovanni
per conto di Edizioni Charta